OK, I admit it… I'm addicted to Zentangle. At the end of the day, I love to relax on the sofa, use my lap board, prop my legs up, and draw tangles.

What better way to wind down after a day at work (or a day with the kids) than to draw wonderful little designs? And when I'm finished, I have a beautiful piece of artwork—perfect for framing or to give as a small gift or thank you to a special friend.

What you'll need to get started

- a pencil
- a black permanent marker—a Pigma MICRON 01 pigment ink pen by Sakura is suggested
- smooth white art paper—a Zentangle die-cut paper tile is suggested (3½" x 3½" [9 x 9cm])

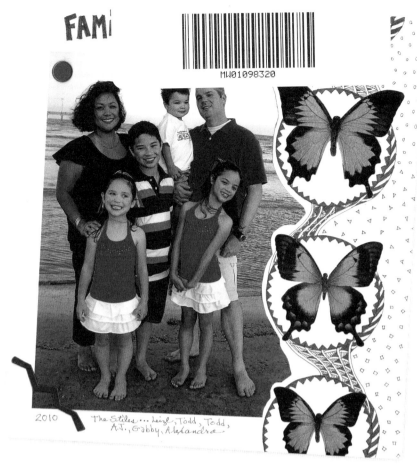

Adhere butterfly rub-ons or stickers, use a circle template to draw a circle around each butterfly, then embellish the border with tangles. Add an 8" x 10" (20 x 25cm) photo (trim to fit the border), journaling, and decorative brads.

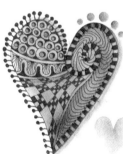

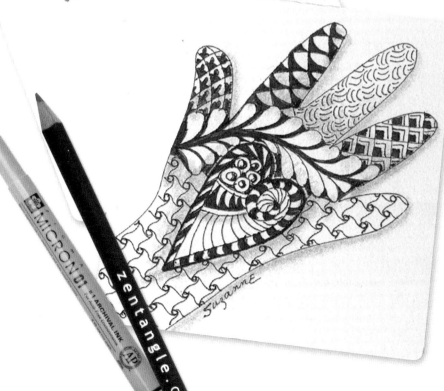

Each tangle is a unique artistic design, and there are hundreds of variations. Start with basic tangles, then create your own.

With the Zentangle method, no eraser is needed. Just as in life, we cannot erase events and mistakes. Instead, we must build upon them and make improvements.

Life is a building process. All events and experiences are incorporated into our learning process and into our life patterns.

Traditional Zentangle

A very simple ritual is part of every classic Zentangle piece.

1. Make a dot in each corner of your paper tile with a pencil.
2. Connect the dots to form a basic frame. The lines don't need to be straight.
3. Draw a string, or guideline, with the pencil. The shape can be a zigzag, swirl, X, circle, or just about anything that divides the area into sections. It represents the thread that connects all the patterns and events that run through life. The string will not be erased but become part of the design.
4. Use a black pen to draw tangles, or patterns, into the sections formed by the string.

Tip: Rotate the paper tile as your fill each section with a tangle.

ZIAs

Traditional Zentangle designs are nonobjective and have no recognizable shape or orientation. The string divides the sections. ZIA is an abbreviation for Zentangle-Inspired Art. Anything tangled with color, not on a square tile, or with a specific orientation is considered a ZIA.

How to Get Started

 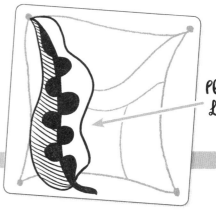

Plum Leaf

Use a pencil to make a dot in each corner.	Connect the dots with the pencil.	Draw a string with the pencil as a guideline. Try a Z zigzag, a loop, an X, or a swirl.	Switch to a pen and draw tangles in each section formed by the string. When you cross a line, change the pattern. It is OK to leave some sections blank.

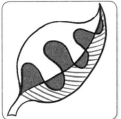 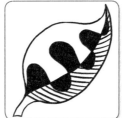 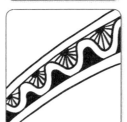 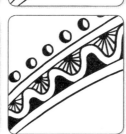

Variation Variation

Plum Leaf

1. Draw a basic leaf shape. Draw a line from the stem to the tip.
2. Draw a wavy line on one side.
3. Color the center section with black. Draw the lines on one side.

Deco Border

1. Draw 2 pairs of lines in a section.
2. Draw a pair of wavy lines inside of the area. Draw small half circles on one side of the area.
3. Draw lines radiating from the half circles. Color the other area with black.

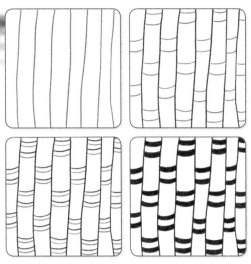

Sugarcane

1. Draw vertical lines in a section.
2. Draw pairs of lines inside of each row to make boxes; alternate the boxes in each row to create a pattern.
3. Add a line on each side of every box.
4. Color the outside of each box with black.

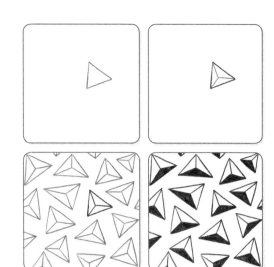

Pyramids

1. Draw a triangle.
2. Draw 3 lines inside of the triangle.
3. Repeat the triangle to fill the space.
4. Shade one section of each triangle with black.

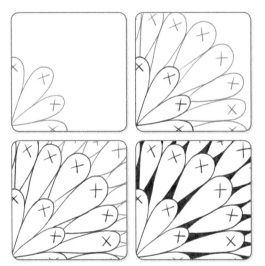

Peacock Tail

1. Draw 3–4 loops in a corner. Draw an X near the top of each loop.
2. Draw more loops radiating from the corner to make a second row.
3. Fill the remaining space with loops.
4. Fill the background space with black.

Shading Your Zentangle

Shading adds a touch of dimension and is very easy to do. First use the side of your pencil to gently color areas and details gray. Then rub the pencil areas with a paper shading tool, a finger, or another tool to blend the gray. Use shading sparingly. Be sure to leave some sections white. You can also try adding shading along the right and bottom edges of your finished shape. Make the shading about ⅛" (0.5cm) wide to visually raise the tangles off the page.

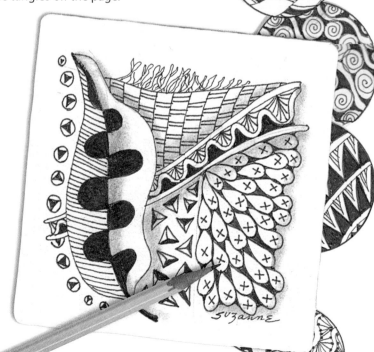

Where to add shading:
- Around the outside edge of a section
- In background spaces
- On one side of a tangle
- Along the edges of a section

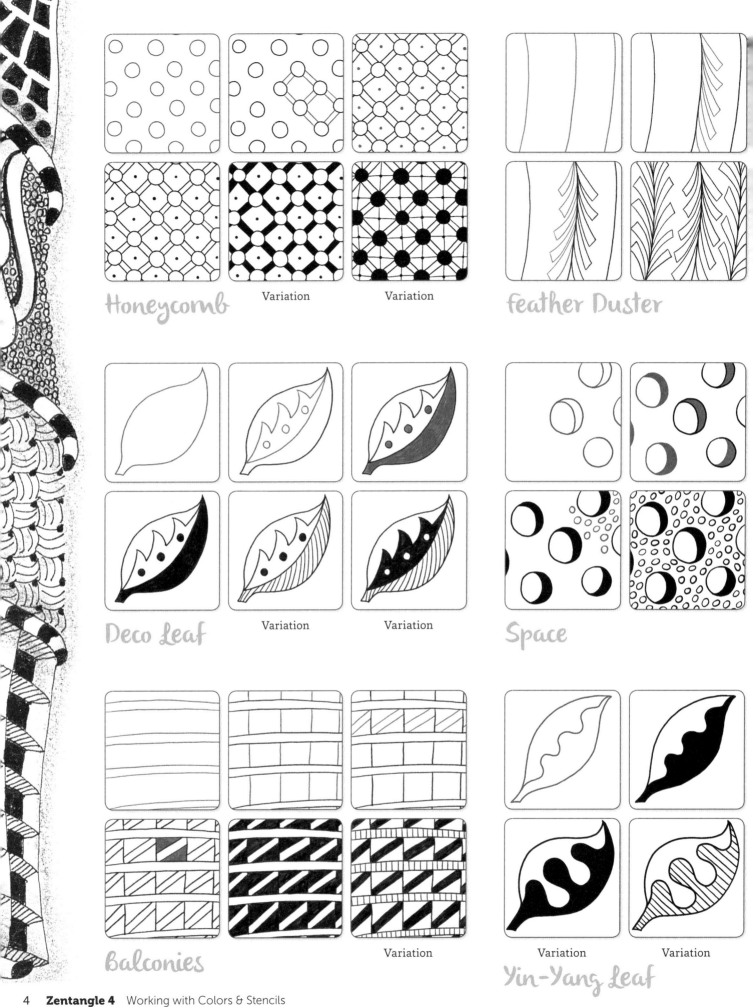

Honeycomb

Variation

Variation

Feather Duster

Deco Leaf

Variation

Variation

Space

Balconies

Variation

Variation

Variation

Yin-Yang Leaf

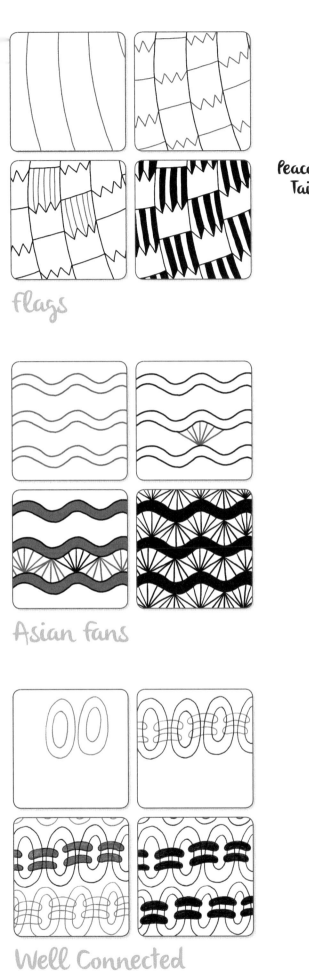

Flags

Asian Fans

Well Connected

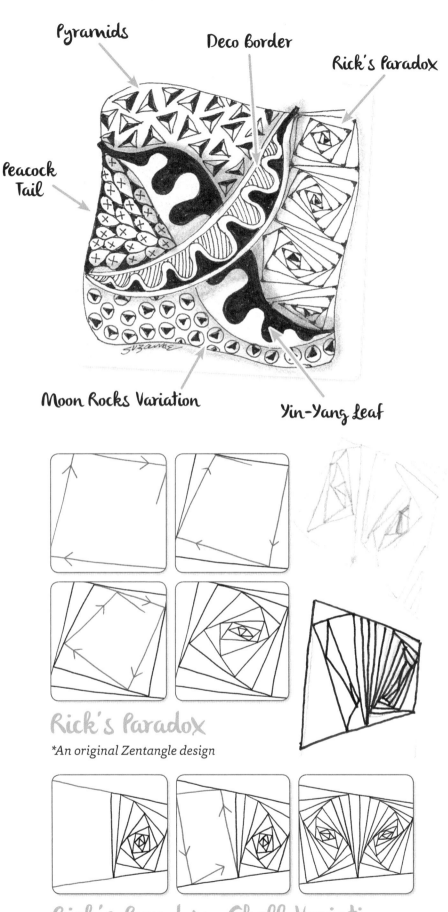

Pyramids

Deco Border

Rick's Paradox

Peacock Tail

Moon Rocks Variation

Yin-Yang Leaf

Rick's Paradox

An original Zentangle design

Rick's Paradox–Shell Variation

Look closely. Draw the same pattern for the second tangle, but draw the lines going in the **opposite direction**. This creates the flared shell design.

Rick's Paradox **Track Lighting** **Berries**

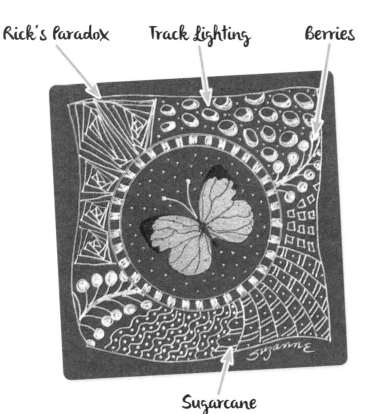

Sugarcane

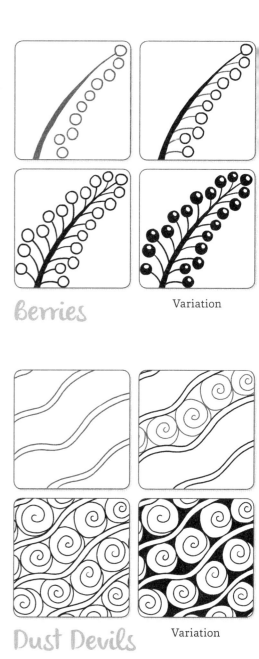

Berries Variation

Dust Devils Variation

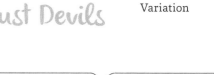

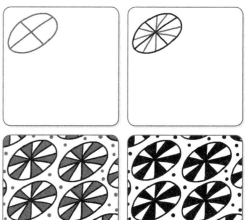

Floating Disks

Thornbush

Dust Devils

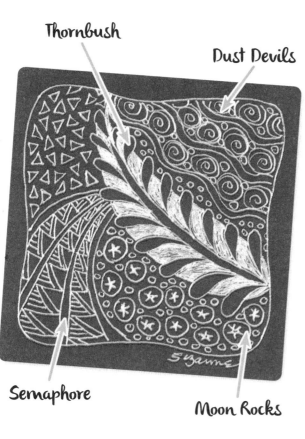
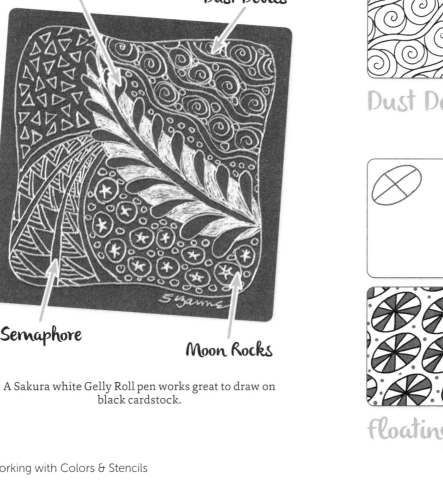

Semaphore

Moon Rocks

A Sakura white Gelly Roll pen works great to draw on black cardstock.

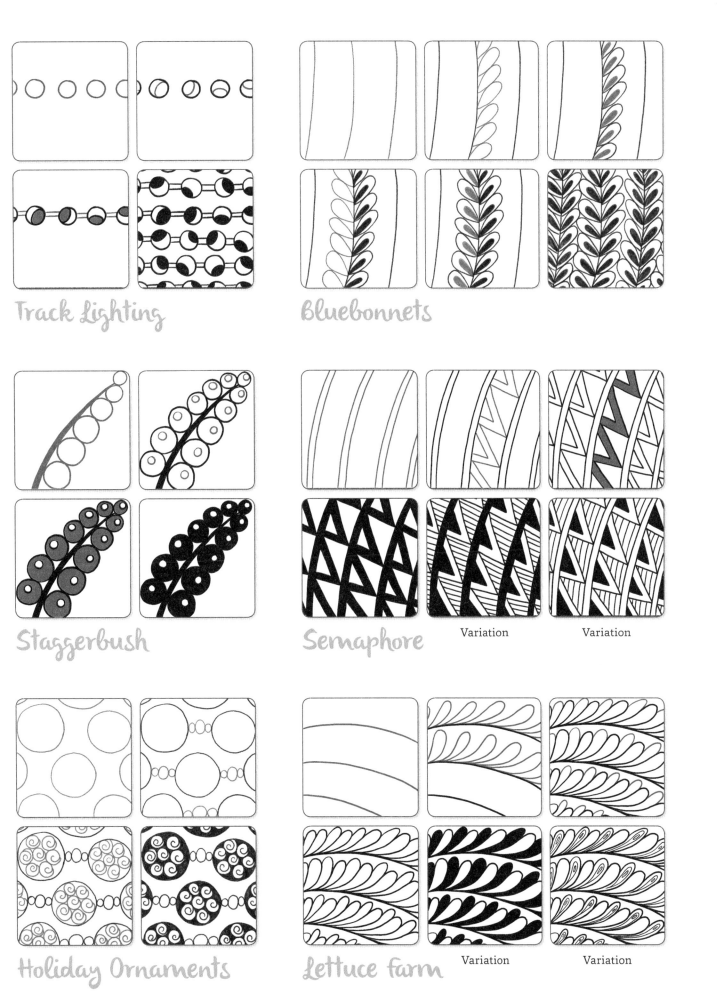

Track Lighting

Bluebonnets

Staggerbush

Semaphore

Variation

Variation

Holiday Ornaments

Lettuce Farm

Variation

Variation

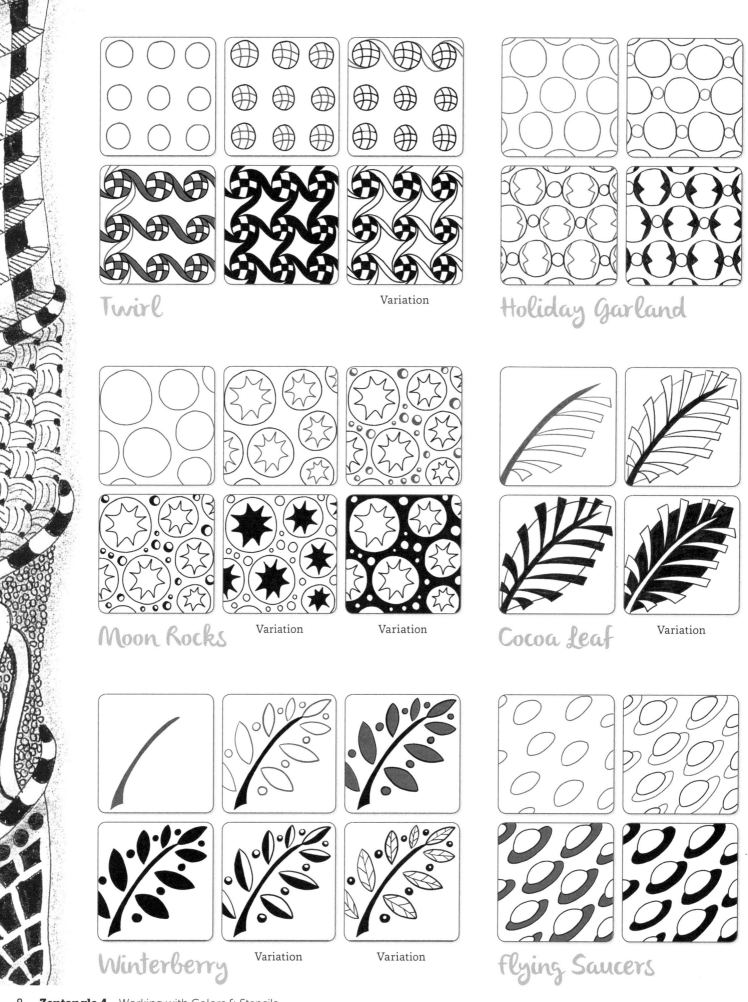

Twirl

Variation

Holiday Garland

Moon Rocks

Variation

Variation

Cocoa Leaf

Variation

Winterberry

Variation

Variation

Flying Saucers

Leaf Stem

White Pine

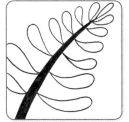

Shiral

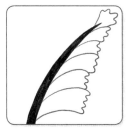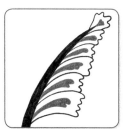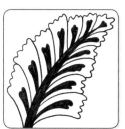

Serrate Frond

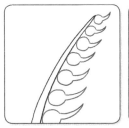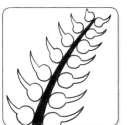

Jacquinia

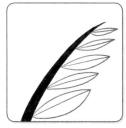

Ash Leaf

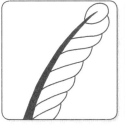

Banana Leaf

Thornbush

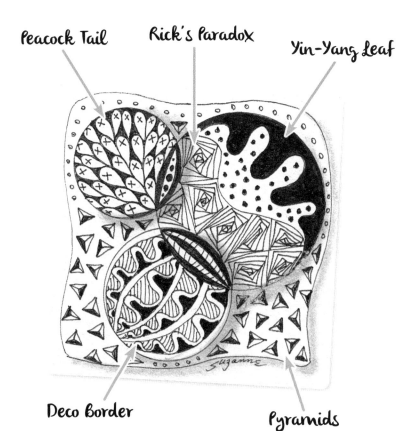

Peacock Tail Rick's Paradox Yin-Yang Leaf

Deco Border Pyramids

Pear Leaf

Tangles on Tiles

Use a stencil, template, or shape as the basis for your string.

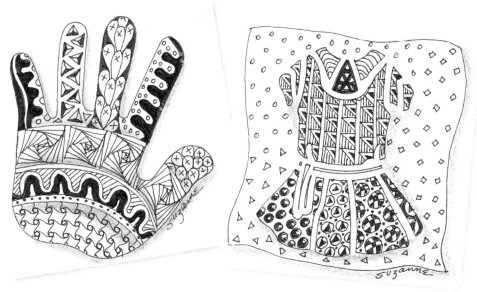

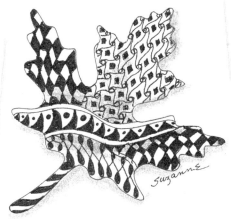

Use a black Pigma MICRON 01 pen to outline the shape. Draw sections within the shape with a pencil.

Add a tangle in each section with a black pen. If desired, add shading with a pencil.

Hand: Draw around a wood cut-out, then tangle inside each section.

Dress: Use a brass stencil to draw the dress design. Draw a tangle inside of each section.

Maple Leaf: Use a leaf template to draw the outline of a leaf, then add tangles.

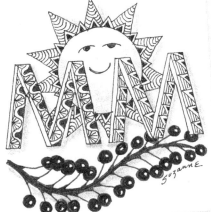

Plastic Templates
Crafter's Workshop:
Alphabet #TCW203
Ginkgo Leaves #TCW192
Birds #TCW185 and Small Birds
Butterfly Ballet #TCW193
Floral Vines #TCW82

Color Templates
Blue with Rooster
Green with Circles
Plaid: Purple with Leaf #29282

Brass Stencils
TSC Designs:
Dress #TMR494
Lasting Impressions:
Hand & Heart #L9122

Additional Shapes
Small wood hand cut-out
Lid from a jar
Plastic circle

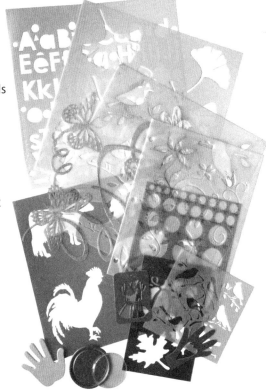

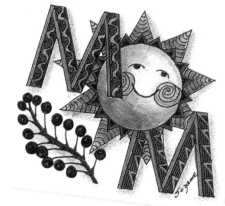

Sunny

MOM: Use a Crafter's Workshop alphabet template to draw MOM. Use the same alphabet for both tiles but arrange the letters and berries in different places. Position the letters as desired. Add a Berries (page 6) tangle below the word. Use Tombow watercolor pens to add colors.

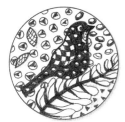

Draw with a black Pigma MICRON 01 pen. Shade with a pencil.

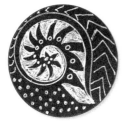

Draw with a Sakura white Gelly Roll pen on black cardstock.

Draw with glitter glue, sprinkle fine glitter on top. Let dry. Remove excess.

Draw with a Versamarker pen, sprinkle embossing powder on top. Use a heat gun.

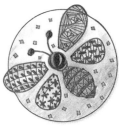

Color with watercolor pencils. Add water. Apply rhinestone gem accents.

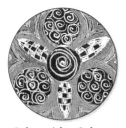

Color with a Sakura white Gelly Roll pen. Add color with Sakura Metallic pens.

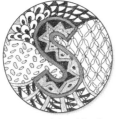

Draw with a black Pigma MICRON 01 pen. Color with Sakura Metallic pens.

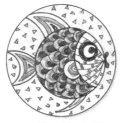

Draw with a black Pigma MICRON 01 pen. Color with colored pencils.

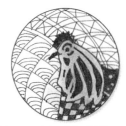

Draw with a black Pigma MICRON 01 pen. Color with chalk.

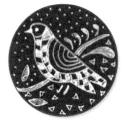

Draw with a Sakura white Gelly Roll pen on black cardstock.

Draw with a black Pigma MICRON 01 pen. Color with Sakura KOI watercolors and a brush.

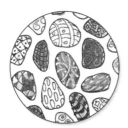

Color with medium. Add Pearl Ex powder or Perfect Pearls. Remove excess.

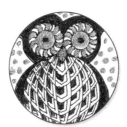

Apply glitter glue. Sprinkle fine glitter on top. Let dry. Remove excess.

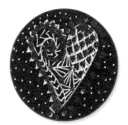

Apply glitter glue. Sprinkle fine glitter on top. Let dry. Remove excess.

Draw with a black Pigma MICRON 01 pen. Color with a Sakura Stardust pen.

Supplies for Coloring

Tattered Angels: Glimmer Mists
Ranger: Color Wash
Art Glitter: Clear glue, glitter colors
Royal Langnickel: Rub-on butterflies
Tsukineko: Embossing ink pen
Sakura: Stardust Gelly Roll pens; Metallic Gelly Roll pens; Moonlight Gelly Roll pens; MICRON set of pens, black set and color set; Microperm pen (for glass); White Gelly Roll pen; Set of KOI watercolors & brush

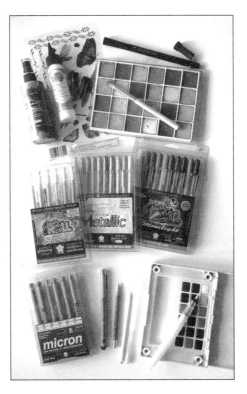

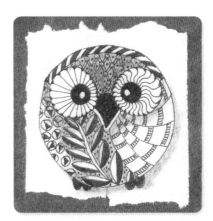

Create a color border by blocking out the center of a tile with masking tape. Spritz color with Ranger Color Wash sprays, then wipe with a paper towel. Let dry. Remove the tape.

Owl

Use a circle template as a guide to outline the body and eyes. Draw sections with a pencil, then add the tangles with a black pen.

Embellish Scrapbook Pages

Use a black Pigma MICRON 01 pen to outline the shape. Draw sections within the shape with a pencil. Add a tangle in each section with the black pen. Add shading with a pencil.

Happy Days Scrapbook Page (left)

Use a Crafter's Workshop alphabet template to draw the words, overlapping letters as desired. Draw flourishes on each corner of the photo with a Floral Vines template. Fill each letter and flourish with tangles. Glue rick-rack to each side of the page. Attach flower petals with brads. Add additional brad shapes in the background. Tie a ribbon on a 2" (5cm) round tag. Write a name and tangle a border, then glue the tag to the page.

Holidays Page (below)

Use a 4" (10cm) cookie cutter to draw the tree shape. Add tangles. Glue a strip of holiday ribbon and large chipboard letters to the page. Glue ribbon roses, star rhinestones, and jewels to the page.

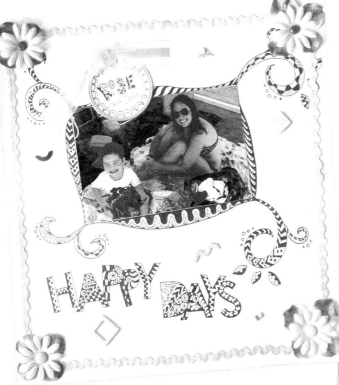

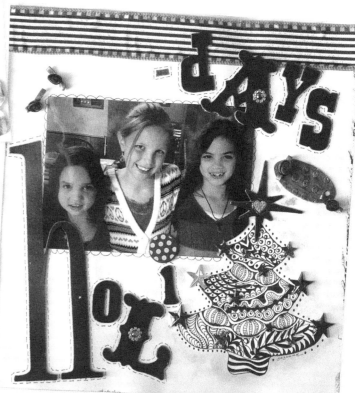

Add Color to Tangles

Use markers, pens, watercolors, and chalks to add color to your tangles. Because Pigma MICRON pens are made from the finest quality permanent ink, they are waterproof and bleedproof.

It is easy to add color after you draw the tangles. Color gives them a life all their own. You'll find alternative ways to color your tangles in this book.

Add a Color Halo
Brush a band of water around the outside edge of a shape. Draw along the outside edge with a Metallic or Starburst pen. The color will bleed in the water and make a halo around the shape.

Use a black Pigma MICRON 01 pen to outline the shape and draw the tangles. Add accents with Sakura Metallic pens.

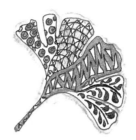

Use a black Pigma MICRON 01 pen to outline the shape and draw the tangles. Add accents with Sakura Starburst pens.

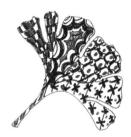

Use a black Pigma MICRON 01 pen to outline the shape and draw tangles. Add accents with Sakura colored MICRON pens.

Memories are Forever

Personalize your precious memories. Use a template to outline shapes on your page. Draw tangles in shapes and titles, then add colors and embellishments as desired.

Butterfly Scrapbook Page

Use a Crafter's Workshop butterfly template to outline the butterfly and the flourish. Use an alphabet template to draw the letters. Fill each flourish and letter with tangles. Stamp three Outlines flowers on white cardstock. Draw tangles on each one. Cut out the flowers, then layer them together. Cut out a pair of leaves. Attach the flower petals and leaves to the page with a large black brad.

Attach flower petals with brads. Add additional brad shapes in the background. Smudge pink chalk on the butterfly shape. Glue a large flower to the page.

Birds Scrapbook Page

Create a dimensional look on heavy cardstock with modeling paste (or molding paste). Apply the paste with a palette knife by scraping a thick layer across a bird template and onto the paper. Scrape off any extra paste before it dries. Gently peel back the template from the paper. Let dry. Center the bird template again. Use a stipple brush to apply colored chalk (Craf-T palette) through the images. Remove excess chalk.

Add a birds border (see instructions above). Rubber Stamp leaves (Outlines #F1045) on white cardstock with Staz-On black ink, then draw tangles in each of the leaves with a black Pigma MICRON 01 pen. Cut around each leaf shape, color the leaves with chalk. Add a 5" x 7" (12.5 x 17.5cm) photo (trim around the head and shoulders), add a title with an alphabet template, draw tangles in each letter, add color with a blue MICRON pen, and add journaling.

Black Scrapbook Page

Use a bird template to draw an outline on black cardstock with a Sakura white Gelly Roll pen, then add tangles in each section. Apply a pearls flourish, then add a ribbon and attach flower petals with brads. Glue star rhinestones in the background.

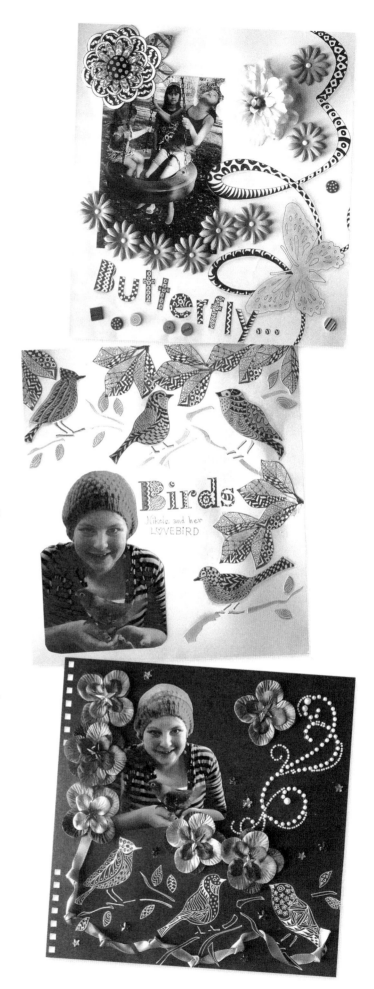

Add Tangles and Color

Brighten up tiles, art journals, scrapbook pages, and cards with color. Here are a few color variations to try.

Use a black Pigma MICRON 01 pen to outline the shape. Draw sections within the shape with a pencil. Add a tangle in each section with the black pen. Add shading with a pencil.

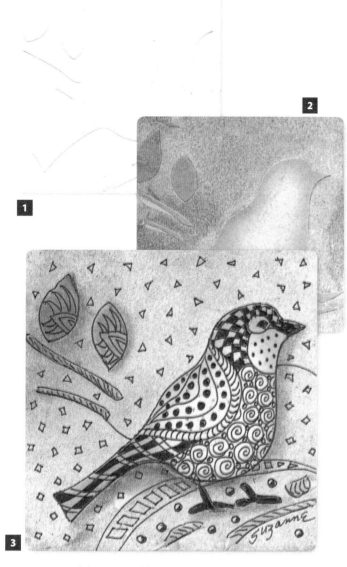

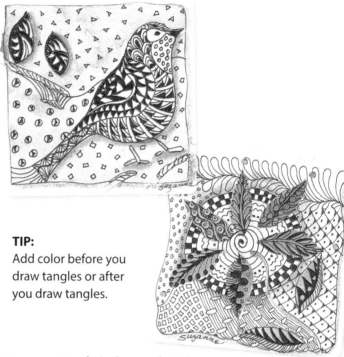

TIP:
Add color before you draw tangles or after you draw tangles.

Green Bird (above left)

Add dimension by pressing modeling or molding paste through a Bird Template (Crafter's Workshop #TCW185) with a palette knife. Let dry. Spray with two colors of Ranger Color Wash. Use a paper towel to wipe off excess color and to blend the colors together. Let dry. Draw the bird and add tangles with a black pen.

Blue Bird (above middle)

Draw the bird with a Bird Template and a black pen. Add tangles with the black pen. Let dry. Use a brush to apply a watercolor wash to the bird and background.

Orange Flower (above right)

Draw the flower with a Floral Vine template and a black pen. Draw sections with a pencil. Add tangles with the black pen. Let dry. Center the template over the flower. Use a stipple brush to apply colors of chalk through the template.

Blue Circle (bottom left)

Use a stipple brush to apply two colors of chalk through a Circle template. Draw sections with a pencil. Draw the tangles with a black pen.

1. Press modeling or molding paste through a template with a palette knife. Allow to dry.
2. Spritz or mist color, then wipe with a paper towel. Let dry.
3. Draw tangles with a black Pigma MICRON 01 pen.

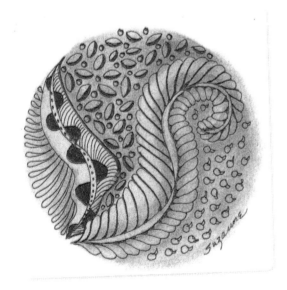

Art Journal Pages

Create a cheery art journal or travel sketchbook. Zentangle is the perfect way to personalize and embellish your pages. I love to relax in the evening with my art journal at hand. I glue a few photos and embellishments in place, then tangle away.

Add tangles in your titles, as borders for pages and photos, add flourishes on the pages, draw accents, and use tangles as fillers.

Add Color to Pages—I used a Strathmore 5½" x 8" (14 x 20cm) Visual Journal with watercolor paper. I color all of my pages at one time before I leave on a trip or begin my journal. Cover a work area with old newspapers. Spritz Ranger Color Wash (Wild Plum, Lettuce, Denim) on the pages, then blend the colors and wipe with a paper towel. Let dry. Glue photos in place as desired.

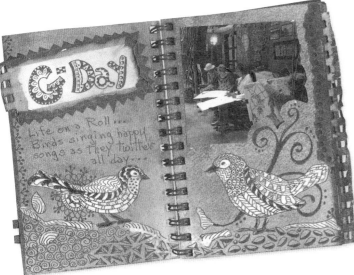

Add color to extra pages. Use these to cut and tear strips, titles, and shapes. Glue these as page accents in your journal or sketchbook.

Cover Page (above right)

Journal with a black Pigma MICRON 01 pen. Glue 3 glass globes (with Zentangle patterns drawn on cardstock underneath) on the page.

Birds Page (above left)

Apply paste through a Bird Template (see instructions on page 14). Journal and add flourishes and words with a black pen.

Flower Page (middle right)

Apply paste through a Floral Vine Template (see page 14). Draw tangles with a black pen and a white Gelly Roll pen.

Travel Page (bottom right)

Draw tangles with a black pen and a white Gelly Roll pen.

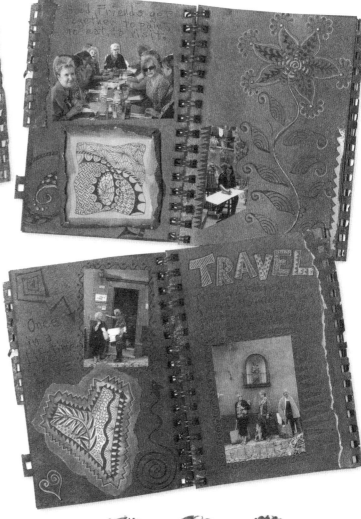

Glass globes with Zentangle underneath.

Art Collage on Canvas

Materials: 9" x 12" (23 x 30.5cm) canvas board; Glass doll; Glitzy buttons, flat-back gems; Die cuts; Metal angel wings; Silk leaves; Paper flower petals; Decorative papers; Chipboard flower with long stem; black Pigma MICRON 01 pen, Microperm pen (draws on glass); Outlines rubber stamps; Staz-On black stamp pad; Gold metallic spray paint; Tattered Angels Glimmer Mists; Heat gun; Zip-dry adhesive; Foam mounting tape

Instructions:

1. Cover a canvas board with decorative paper.
2. Stamp Outlines flowers on white cardstock. Draw tangles on each with a Pigma MICRON pen. Spray with Glimmer Mist and dry with a heat gun. Layer the flowers, add bling or button to each center.
3. Die cut 2 butterflies, a bird cage, a bird, bracket label, and swirly vines with leaves. Draw tangles on the bird and butterflies. Adhere flower petals and silk leaves to the bird to form wings. Cover the bracket label with decorative paper. Spray paint the bird cage.
4. Draw tangles on the glass doll (with a Sakura Microperm pen) and chipboard flower (with the MICRON pen).
5. Stamp, tangle (with the MICRON pen) and cut out letters to spell a word.
6. Arrange elements on the canvas board as desired and adhere with Zip Dry glue. Use foam mounting tape to raise some elements.

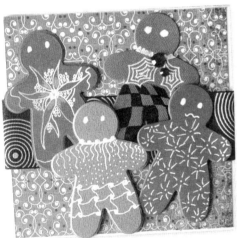

by Kate Farricker,
absolutelyeverything.com

Ginger Cookies (bottom left)

Materials: 5" x 5¼" (12.5 x 13cm) card; 5" x 5" (12.5 x 12.5cm) decorative paper; Flat back gems; Ribbon; 4 die cut gingerbread men; White permanent marker; Zip-dry adhesive

Instructions: Cover the front of the card with decorative paper. Add ribbon. Draw tangles on each gingerbread man. Adhere gems. Adhere to card.

O Christmas Tree (top left)

Materials: 5" x 7" (12.5 x 17cm) card; 4½" x 5½" (11.5 x 14cm) white cardstock; Glitzy buttons; Embroidered lace & ribbon; Decorative papers; Outlines rubber stamps; Staz-On Black stamp pad; Colored markers; Glitter; Zip-dry adhesive

Instructions: Cover the front of the card with decorative papers. Add ribbon and lace. Stamp the trees on white cardstock and draw tangles on each one. Color with markers. Sprinkle lightly with glitter. Adhere strip of lace above the trees. Adhere to card. Adhere a button at the top of each tree.

Zentangle 4 Workbook

Welcome to the *Zentangle 4* workbook, where you will be able to put all the knowledge you've gained about using the Zentangle method into practice. If you'd like to practice the basics, turn the page to get started with some Draw-it-Yourself tangles. In no time at all, you'll master the tangles you can use in your Zentangle art. If you already have some experience with the tangles, you might want to skip right to the shading practice. For tanglers of all levels, there are pages to fill with reverse tangles—using white on black. There are shapes and templates of all sizes to tangle in, and try different materials to add color.

You'll notice that these pages have lots of space on them, and it's all for you! Just because a page might direct you to try a certain exercise there doesn't mean you have to. Use any blank space to draw shapes, tangles, or Zentangle art—whatever you want! This is your place to play, experiment, and create.

Don't be intimidated. Just like there are no mistakes in Zentangle, you can't do anything wrong in this workbook. These pages are yours to do with as you please. If a tangle does not turn out quite the way you intended, find a new blank space and try again. Take what you learned from your first try and apply it to your second. Keep drawing, and you'll be amazed at the results.

Draw-it-Yourself Tangles

Want to practice the steps of a tangle? Here's your place to experiment. Try recreating the tangles, step by step, and use the extra boxes and space to create your own variations and adaptations.

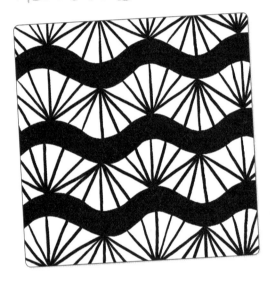

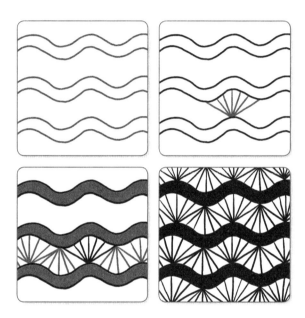

Draw it yourself!

Honeycomb

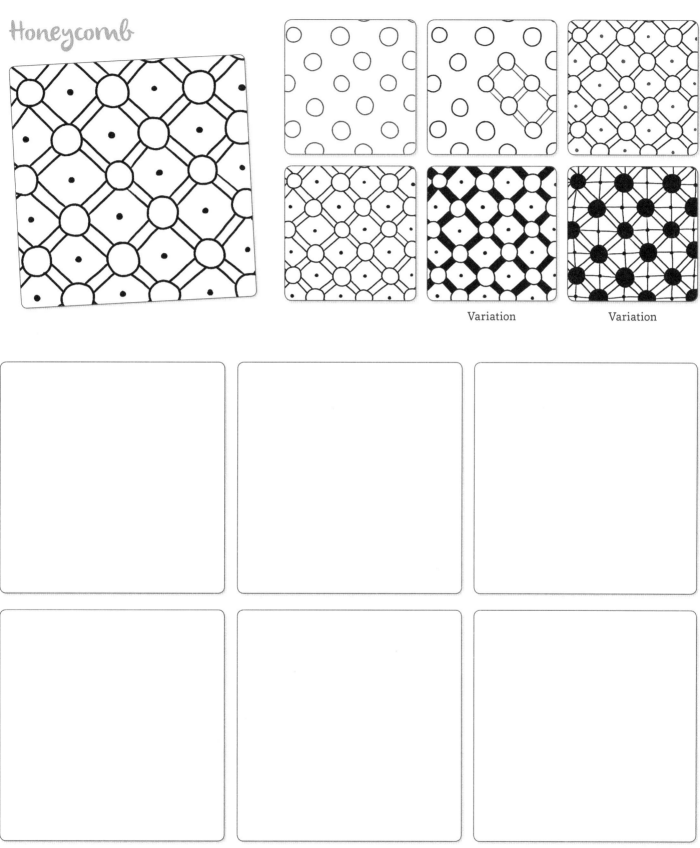

Variation

Variation

Draw it yourself!

Semaphore

Variation

Variation

Draw it yourself!

Twirl

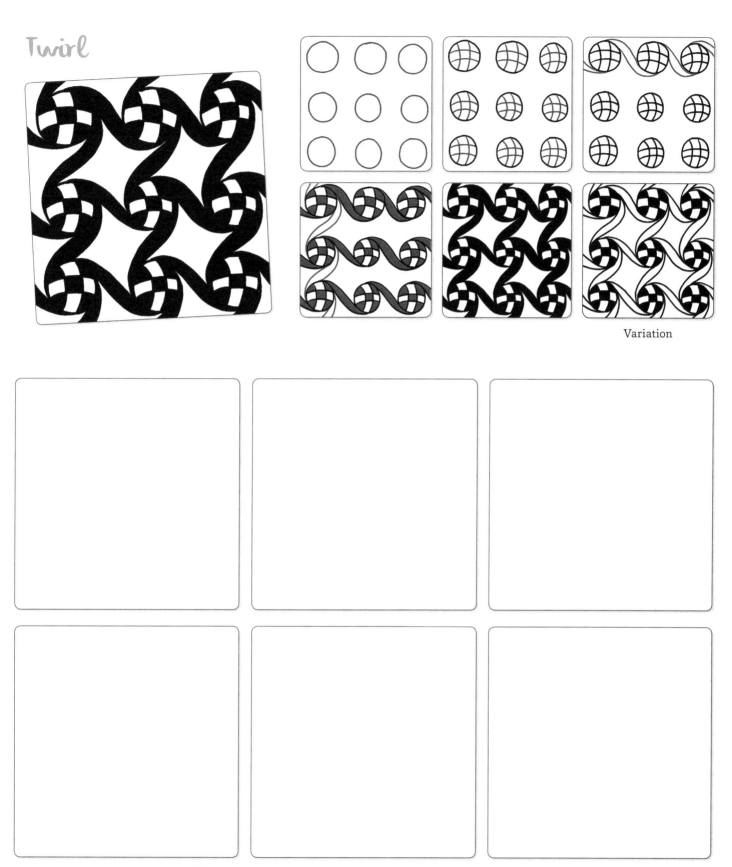

Variation

Draw it yourself!

Practice Shading

Shading is an easy way to add depth and dimension to your Zentangle art. Look at some of the shading samples that follow. The exact same tangles can be made to look completely different through shading. When shading a tangle, think about its shape. Does it have lots of curves? Try shading above or below them. What would the tangle look like if you shaded it from the inside out, or from the outside in? If you're still not sure, get started by shading just the bottom and right side of your tile.

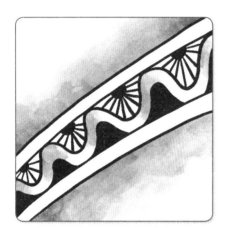

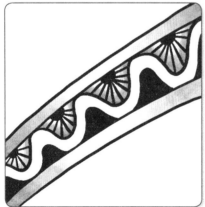

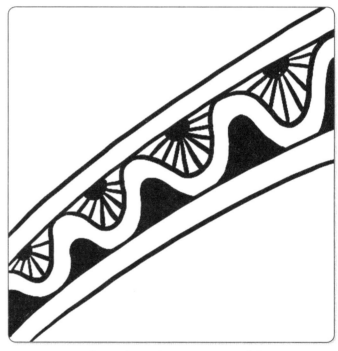

Shade it yourself!

Shade it yourself!

Shade it yourself!

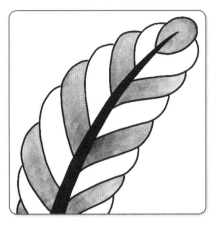

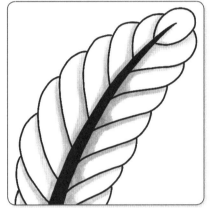

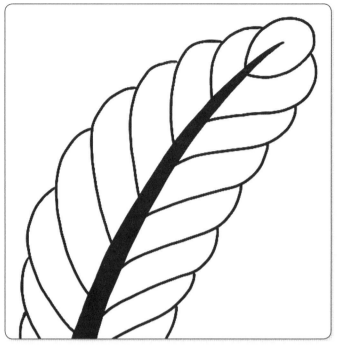

Shade it yourself!

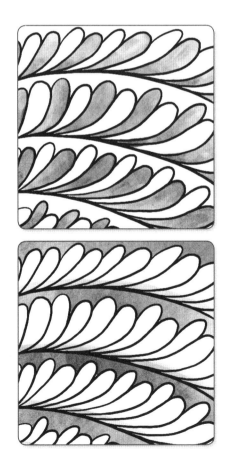

Shade it yourself!

Shade it yourself!

Shade it yourself!

Reverse Tangles

You can get a great reverse effect by using a white gel pen on a black background. Try using the already drawn strings to create a reverse piece of Zentangle art. Or, if you want to really make your art pop, add some color with neon and bright gel pens.

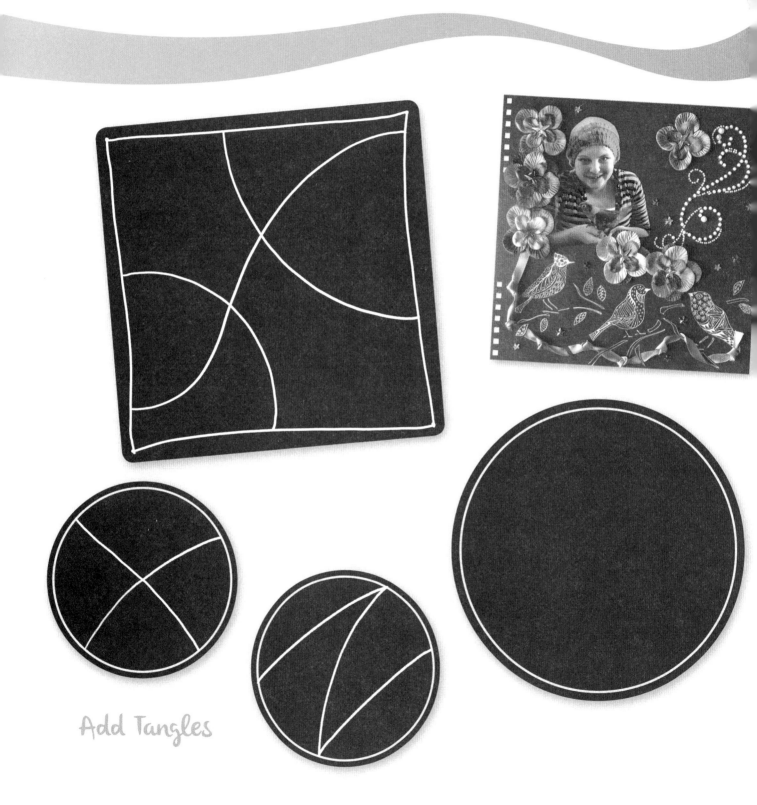

Add Tangles

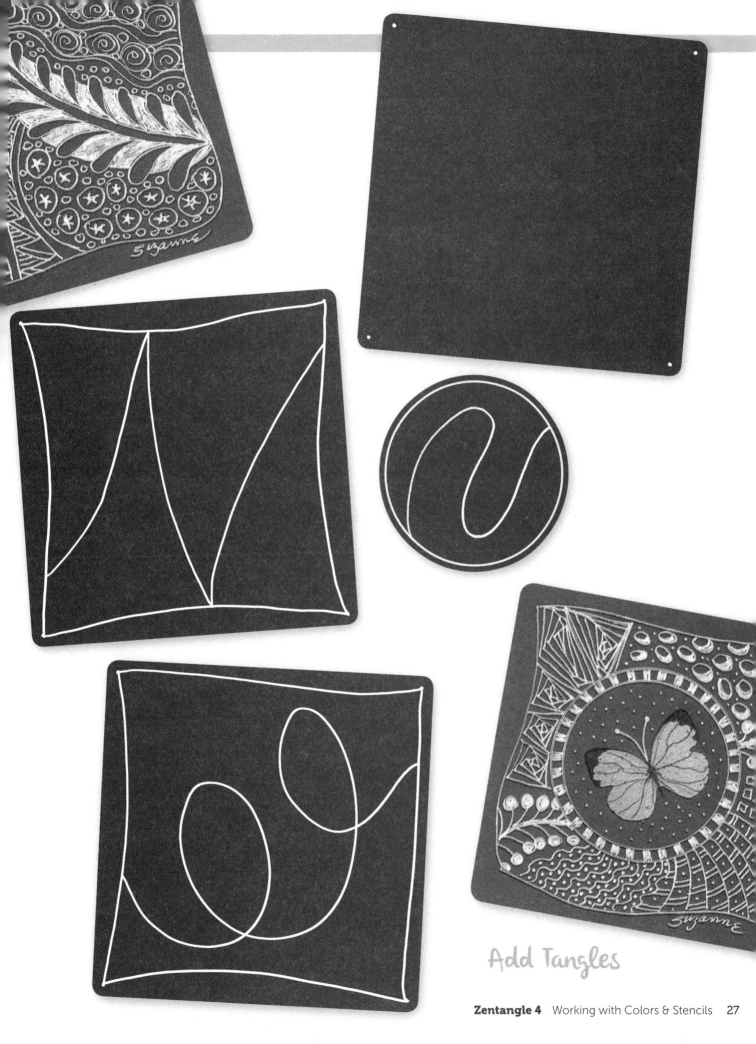

Add Tangles

Tangling Shapes and Stencil Designs

Throughout the pages of this book, you've seen how shapes and stencil outlines can be transformed with tangles to create beautiful Zentangle art. These pages contain some of the stencil designs found in this book so you can practice adding tangles to them. If you're having trouble getting started, take a look back at the tangled designs for inspiration. Or, start by selecting a tangle you'd like to try and add it to the stencil design to get going. There are lots of ways to enhance these designs. Let your imagination run wild and see what you can come up with!

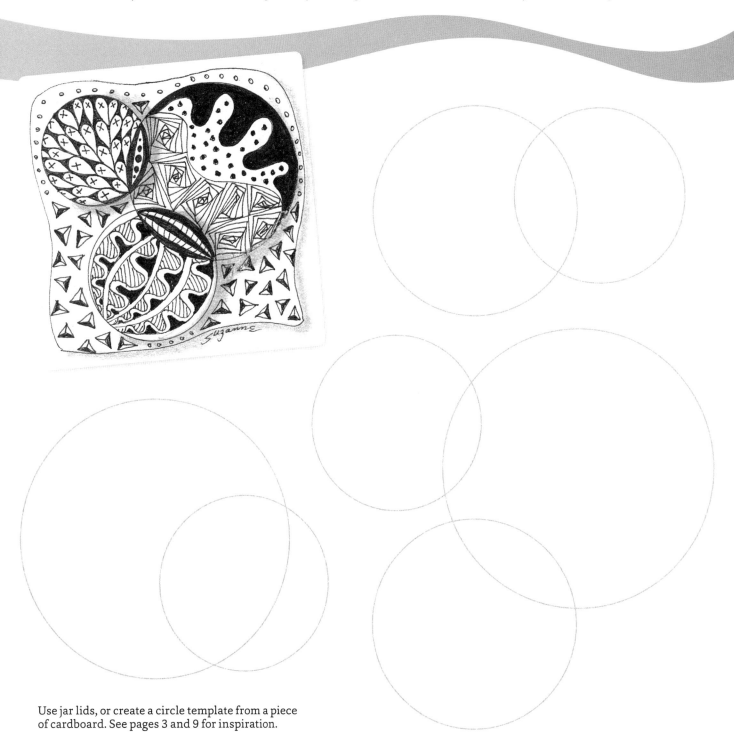

Use jar lids, or create a circle template from a piece of cardboard. See pages 3 and 9 for inspiration.

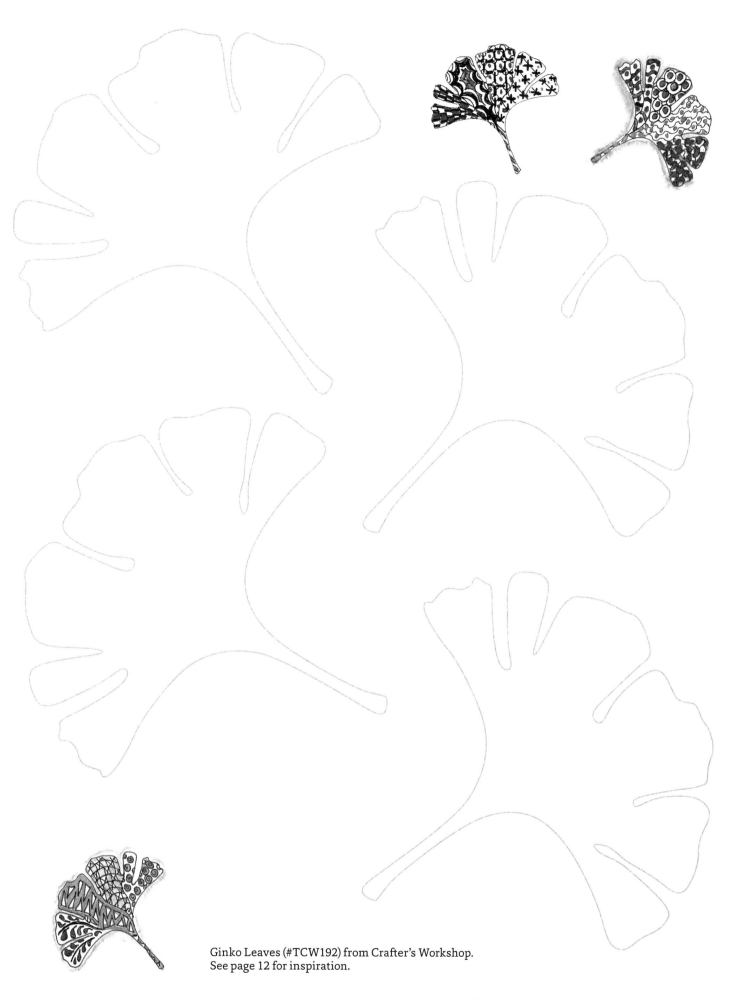

Ginko Leaves (#TCW192) from Crafter's Workshop.
See page 12 for inspiration.

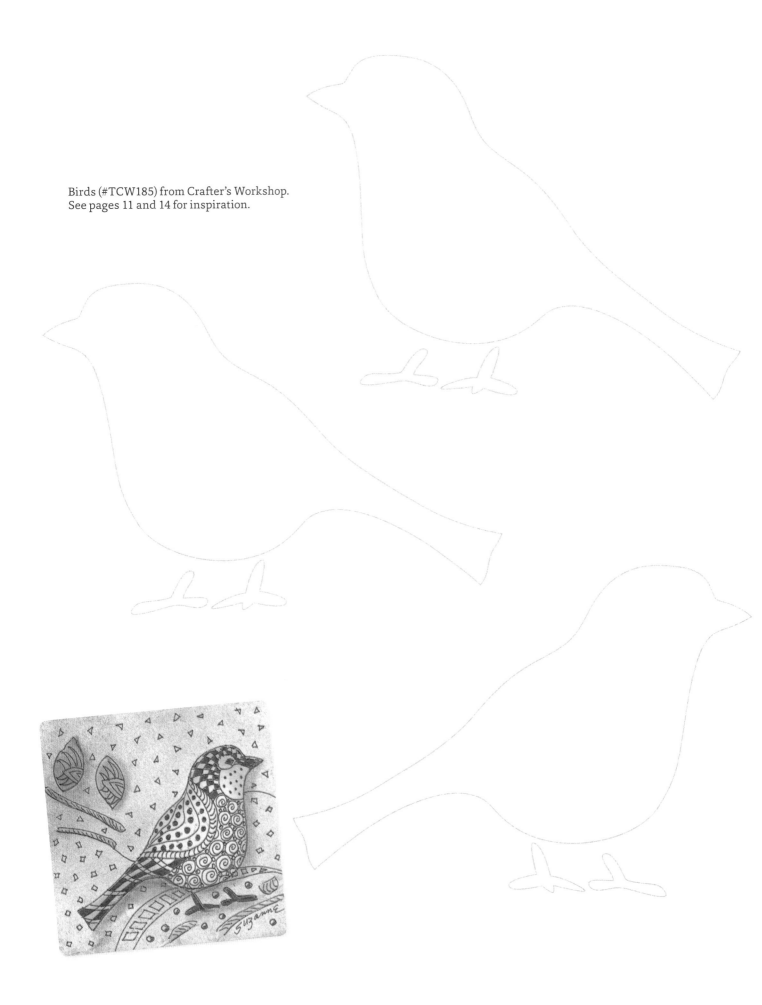

Birds (#TCW185) from Crafter's Workshop.
See pages 11 and 14 for inspiration.

Wooden hand cutout. See page 10 for inspiration.

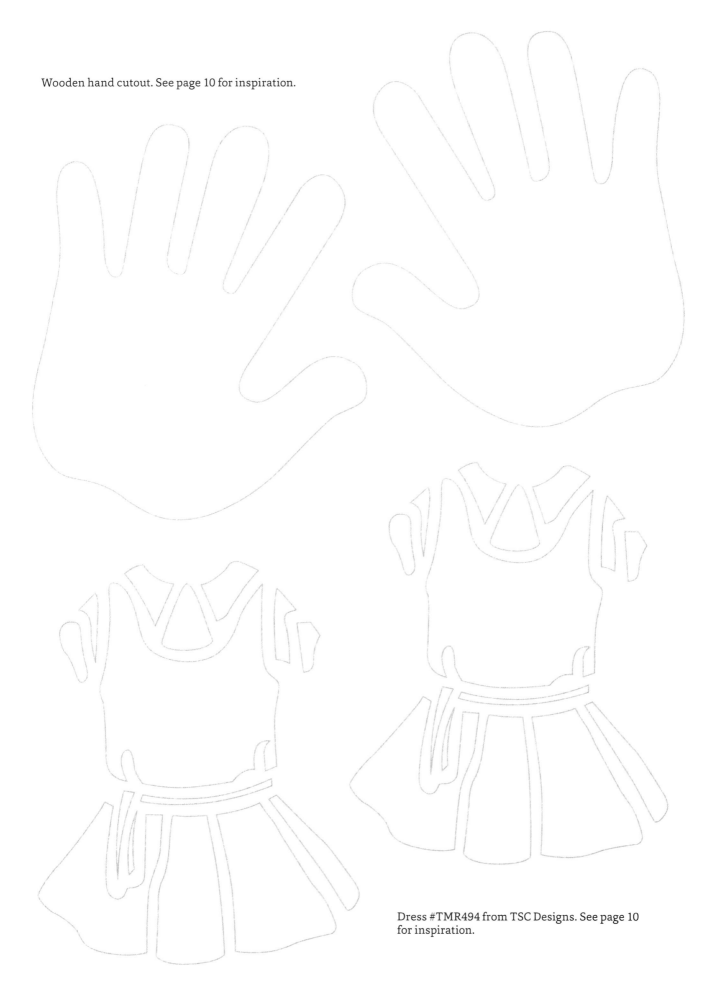

Dress #TMR494 from TSC Designs. See page 10 for inspiration.

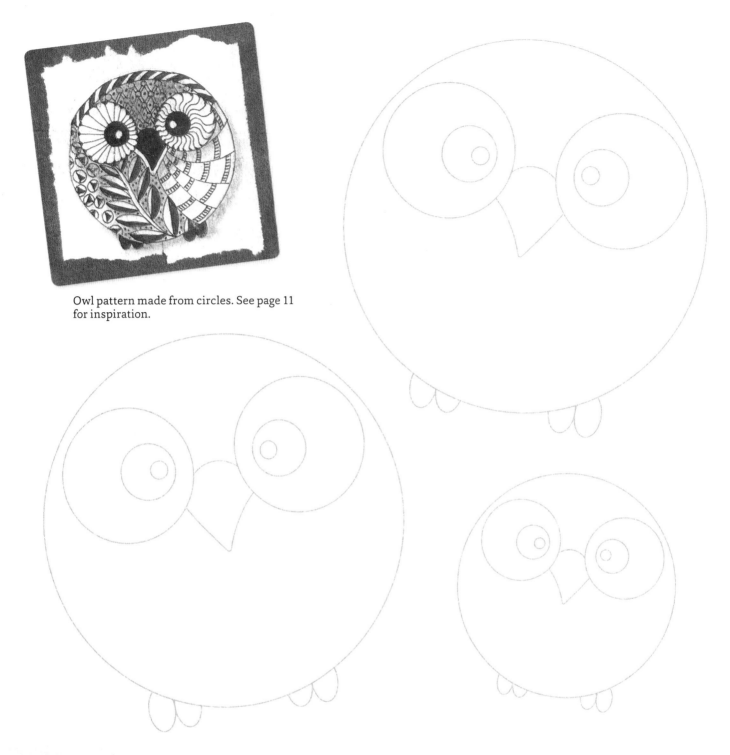

Owl pattern made from circles. See page 11 for inspiration.

ZENTANGLE®

"Zentangle®," the red square, and "Anything is possible, one stroke at a time" are registered trademarks of Zentangle, Inc. The Zentangle teaching method is patent pending and is used by permission.

You'll find wonderful resources, a list of workshops and Certified Zentangle Teachers (CZTs) around the world, a fabulous gallery of inspiring projects, kits, supplies, tiles, pens, and more at *zentangle.com*.

SUPPLIERS

Most stores carry an excellent assortment of supplies. If you need something special, ask your local store to contact the following companies.

INK PENS and MARKERS

SAKURA, PENS and WATERCOLORS, *www.sakuraofamerica.com*

TEMPLATES, STENCILS and ADDITIONAL SUPPLIES

ART GLITTER, GLITTER GLUE & GLITTER, *www.artglitter.com*
CRAFTER'S WORKSHOP, *www.thecraftersworkshop.com*
CRAF-T, *www.craf-tproducts.com*
LASTING IMPRESSIONS, *www.lastingimpressions.com*
OUTLINES, *www.outlinesrubberstamp.com*
PLAID, *www.plaidonline.com*
TSC DESIGNS, *www.teacherstamp.com*
RANGER COLOR WASH SPRAYS, *www.rangerink.com*
ROYAL LANGNICKEL, *www.artusa.royalbrush.com*
COLORFIN, *www.softart.com*
STRATHMORE, *www.strathmoreartist.com*
TATTERED ANGELS, *www.mytatteredangels.com*
TOMBOW, *www.tombowUSA.com*
TSUKINEKO, *www.tsukineko.com*